Graffiti cholos
Charaters by betojimenez

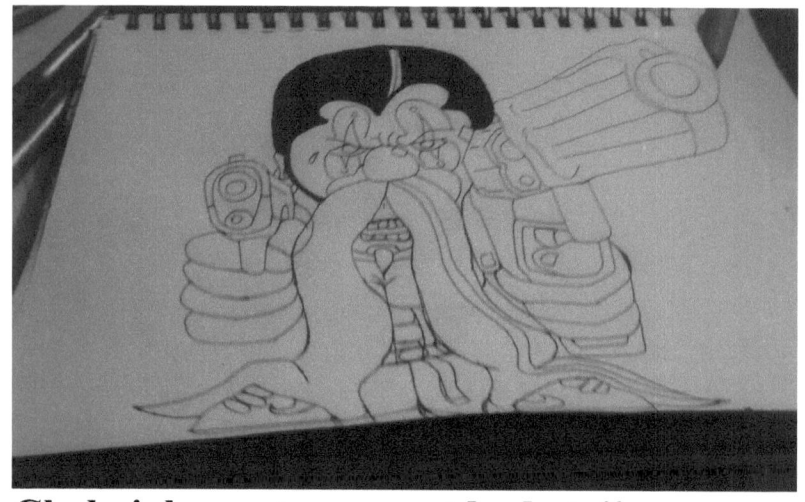

Cholo joker veterano art by betojimenez

When i first start my drawings i do them in pencil so i am able to erase the mistakes i did an didnt like, once i like the drawing how it came out, then i go over it with a black pen then after with a fine black marker, then the art is ready to be painted with markers.

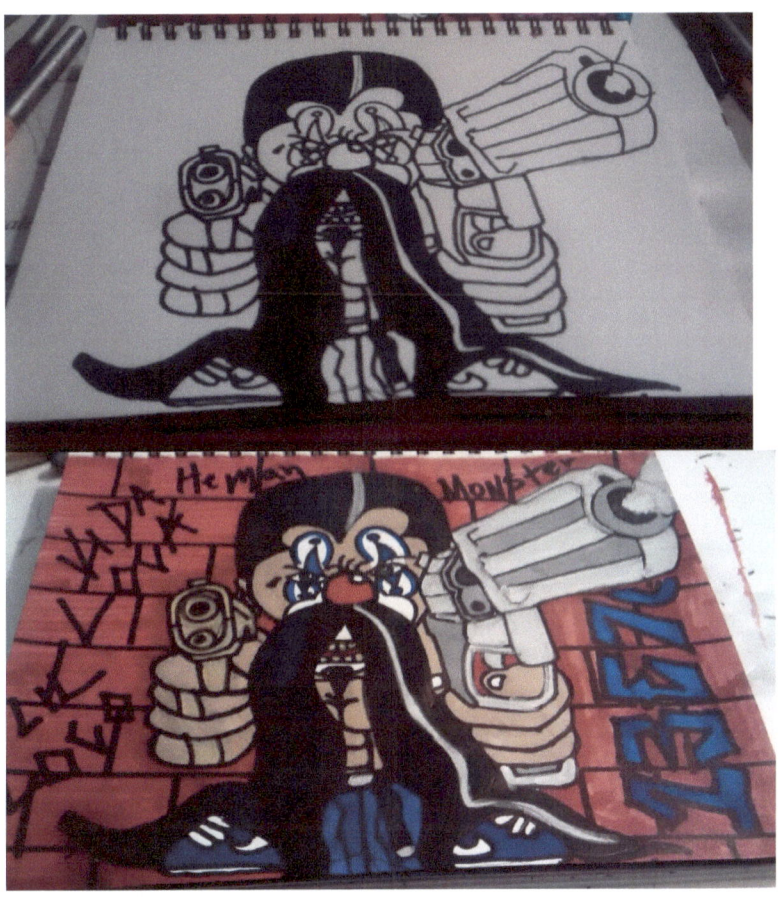

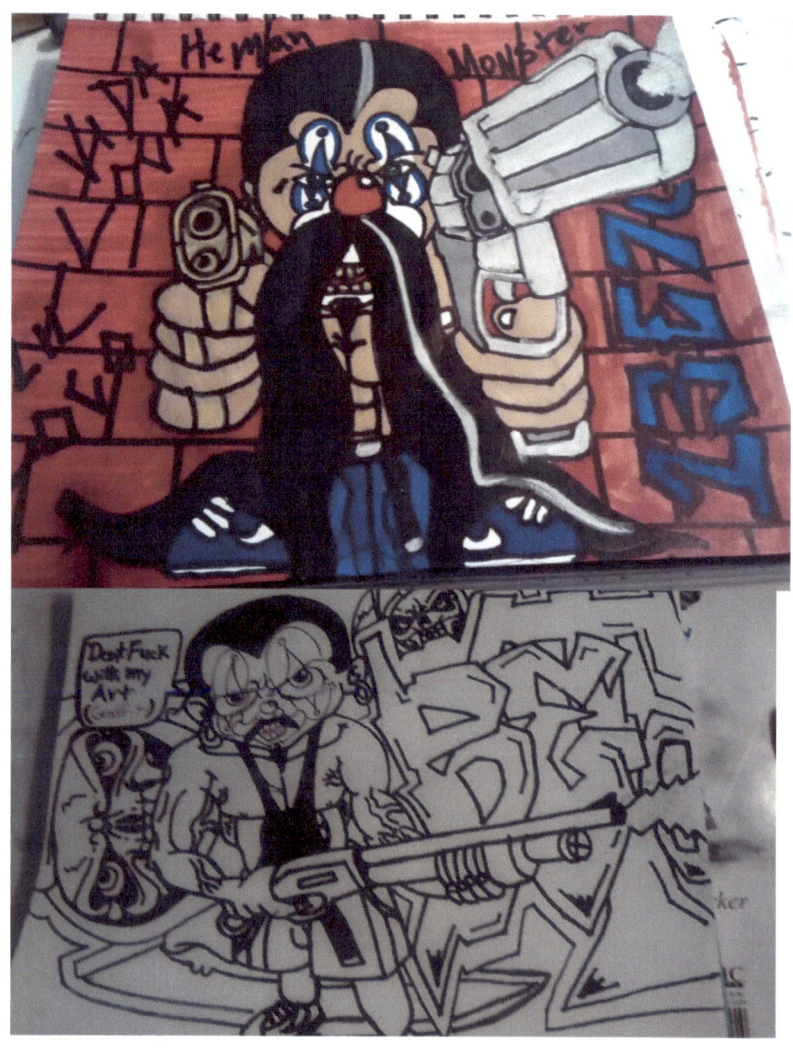

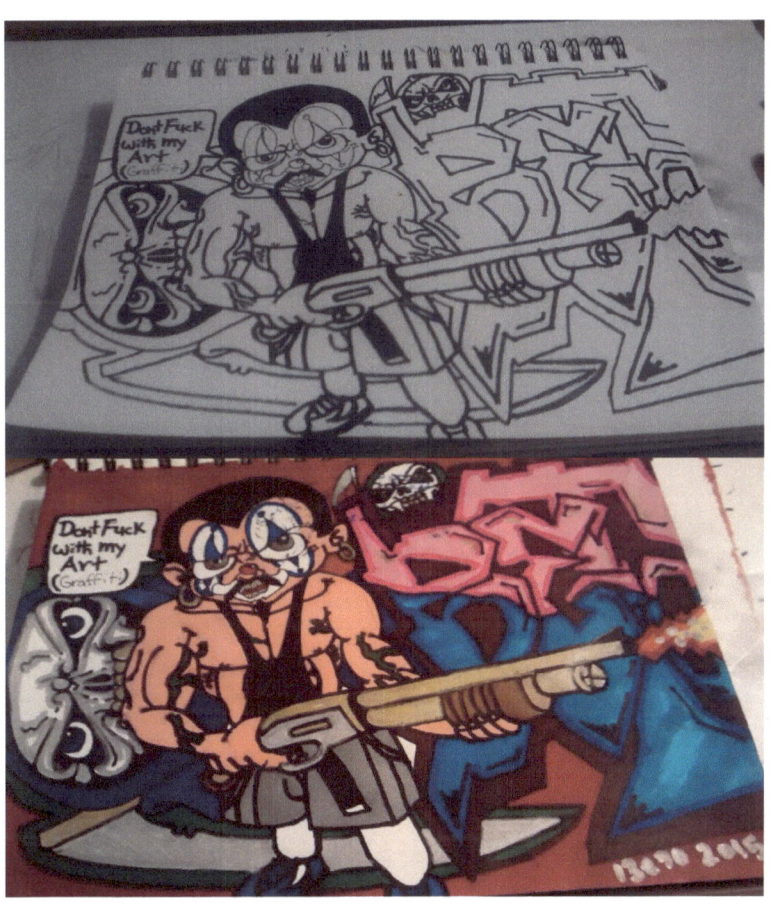

Young peewee cholo art by betojimenez

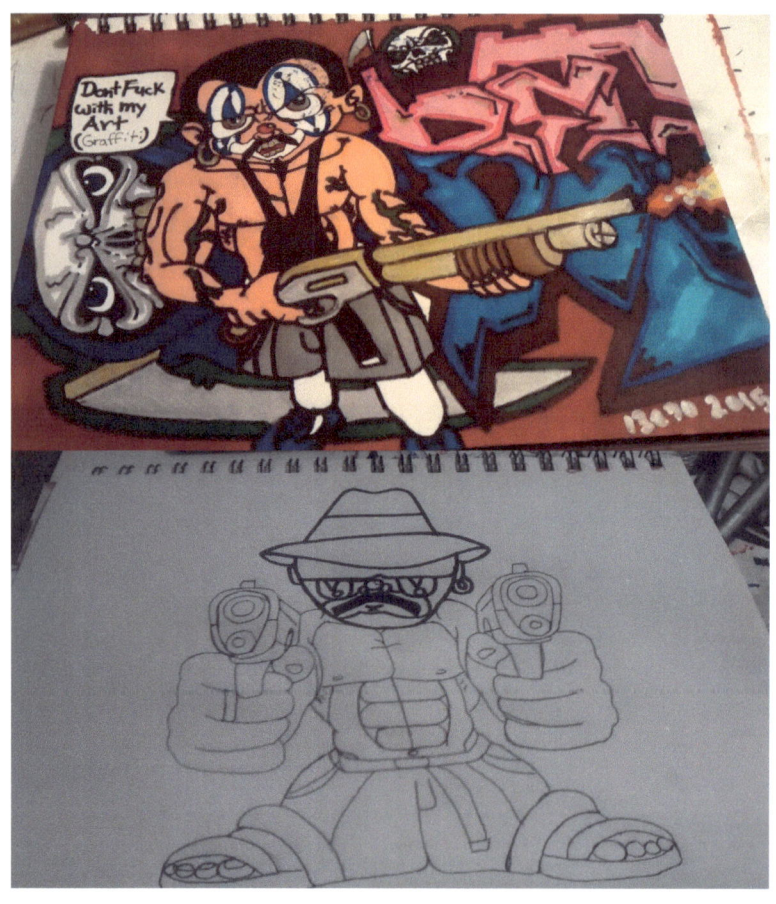

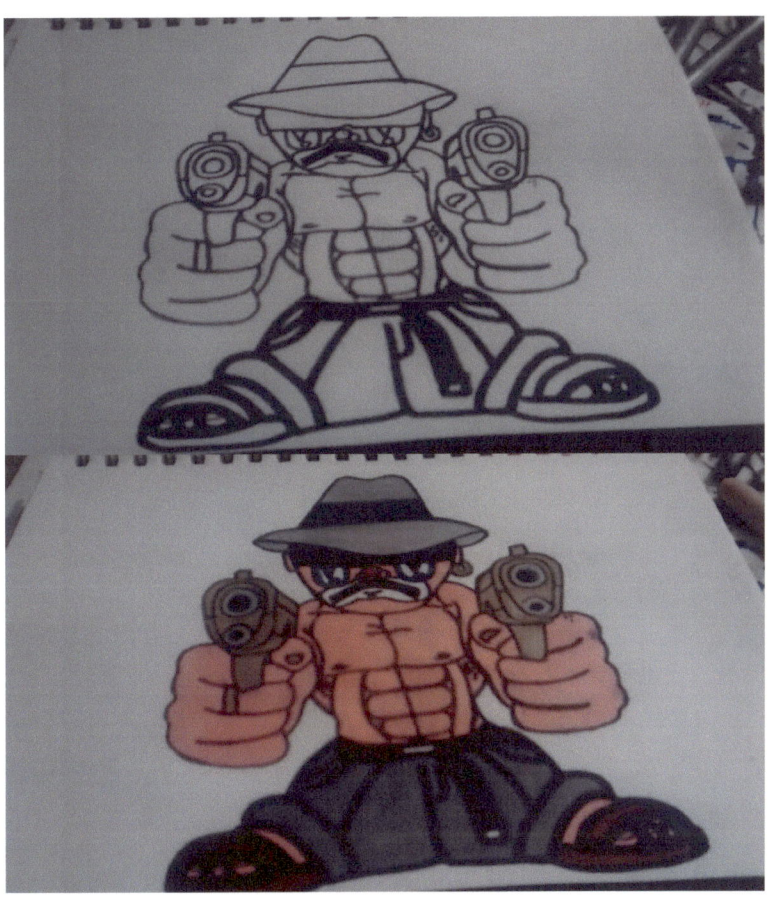

Young Veterano cholo art by betojimenez

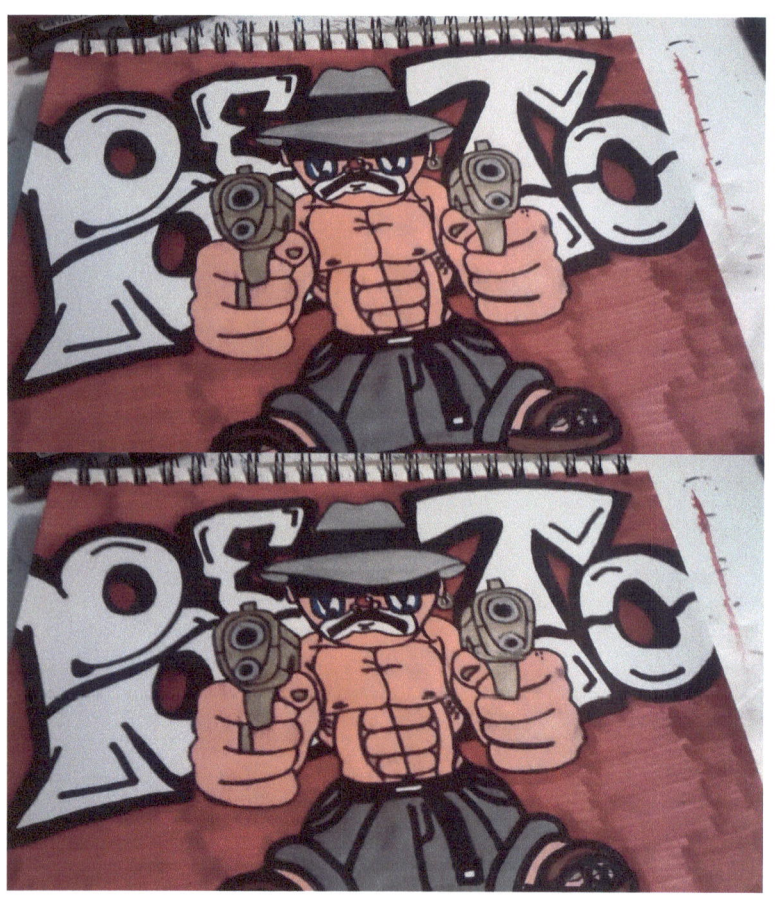

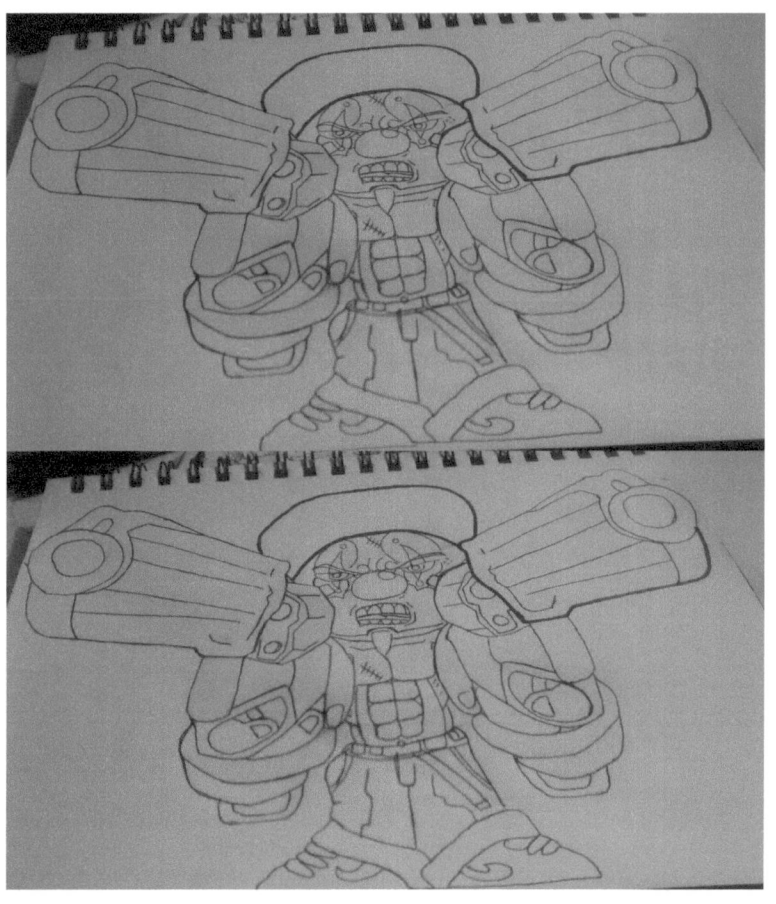

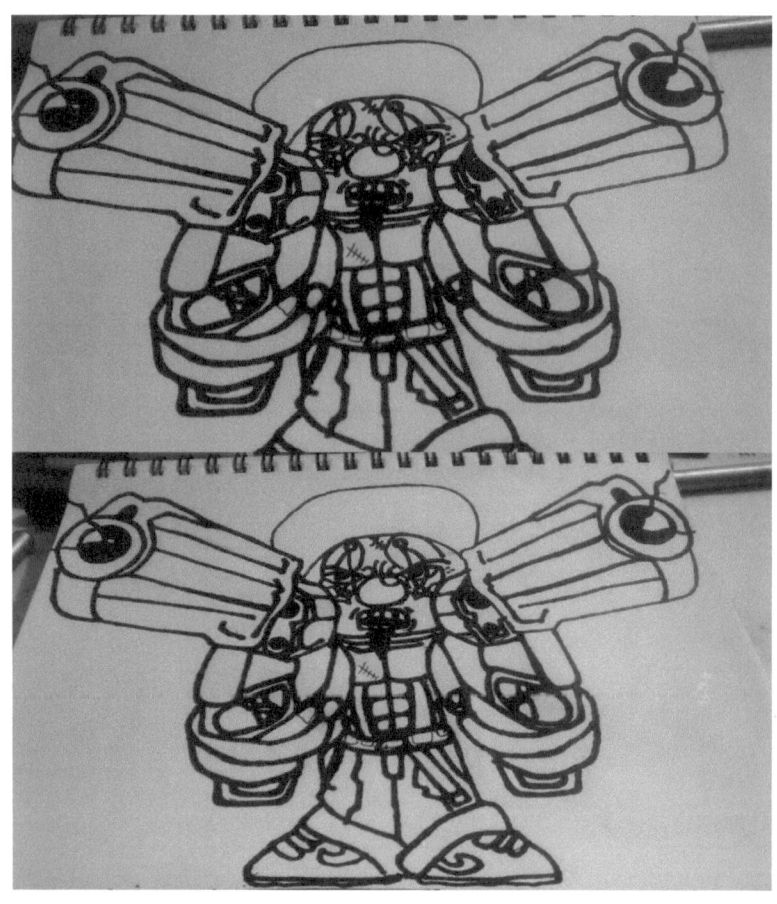

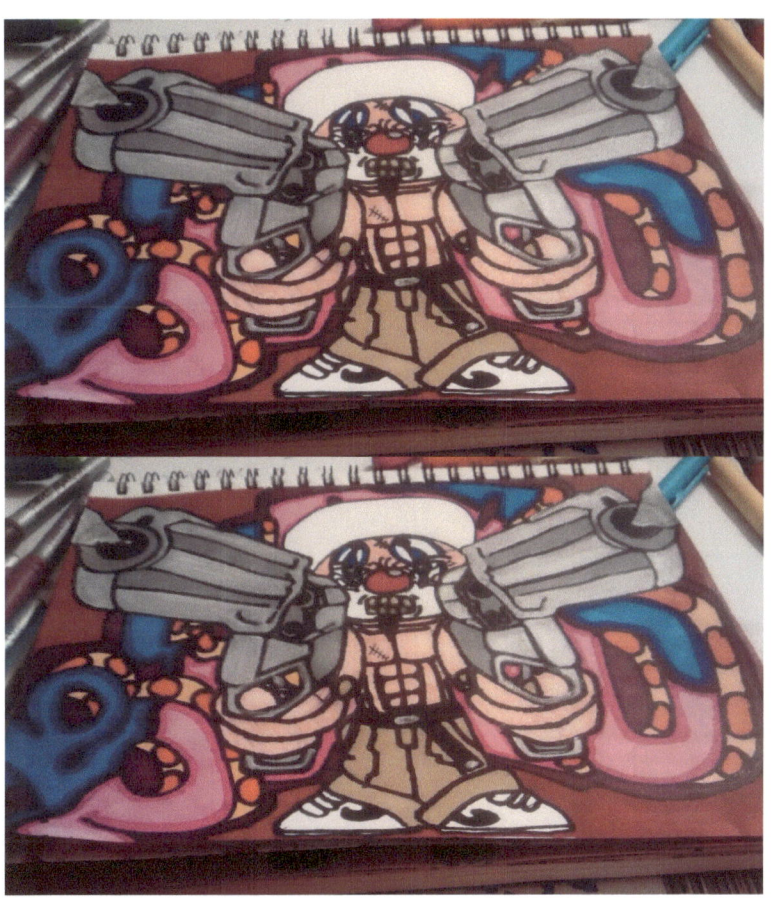

Cholo soldado art by betojimenez

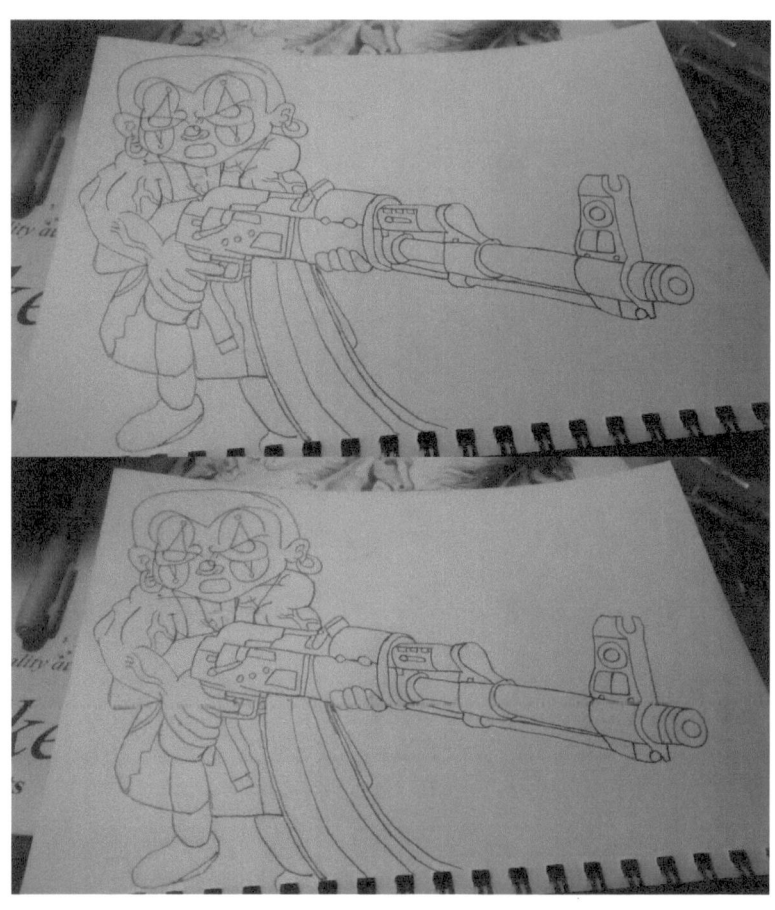

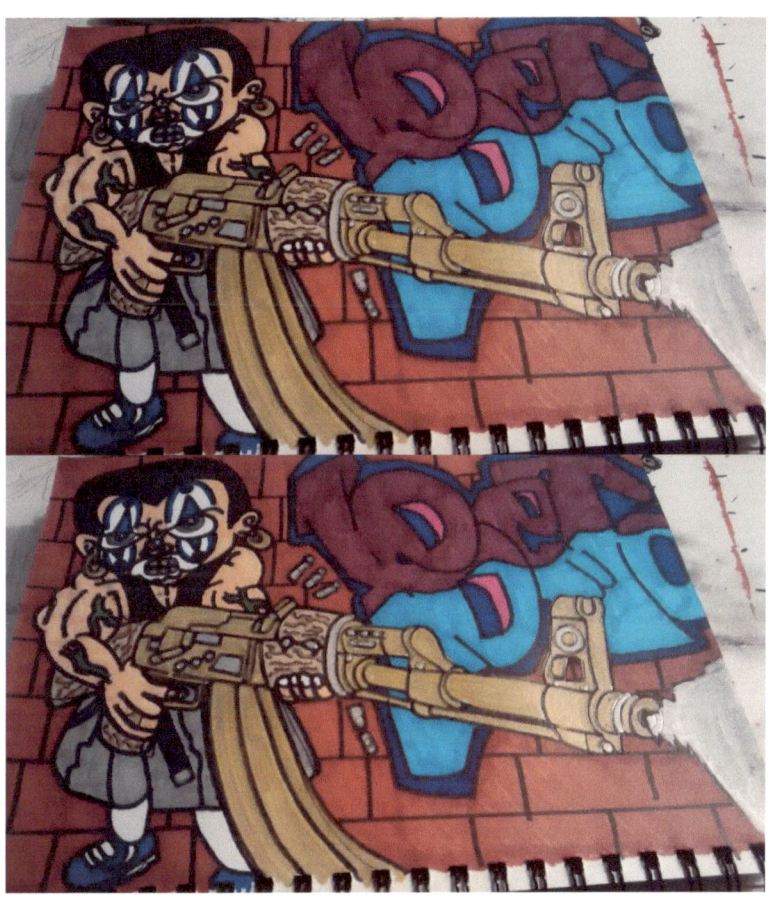

Cholo General art by betojimenez

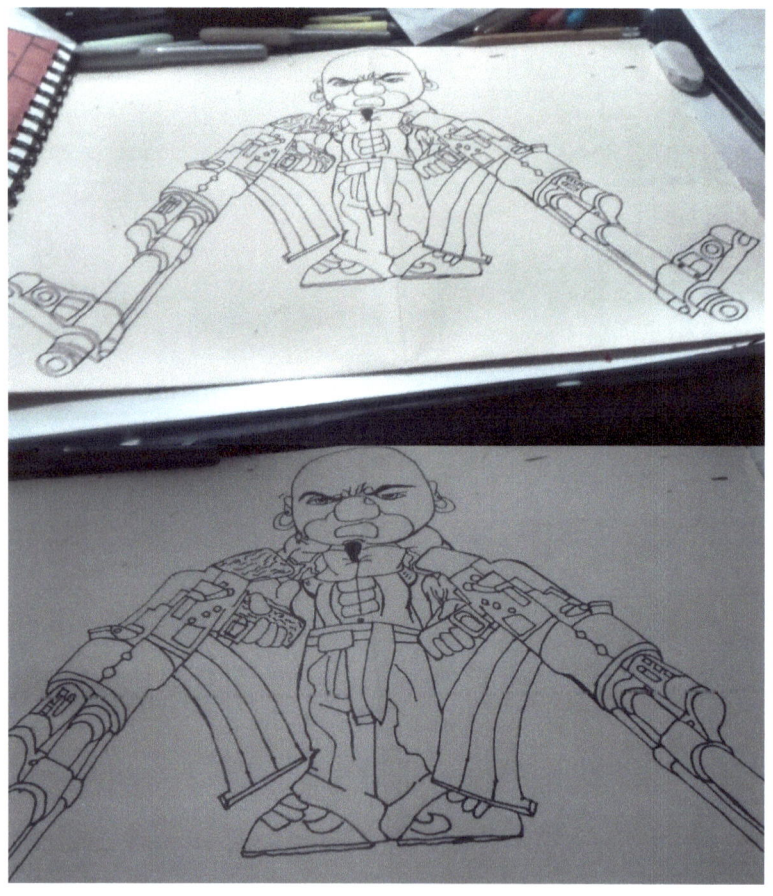

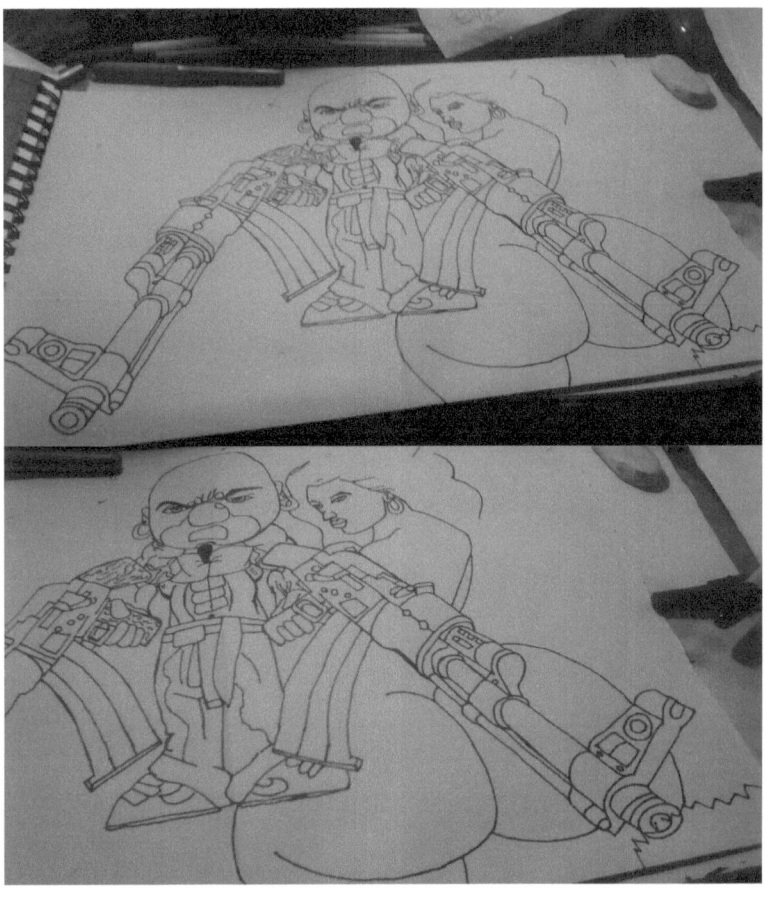

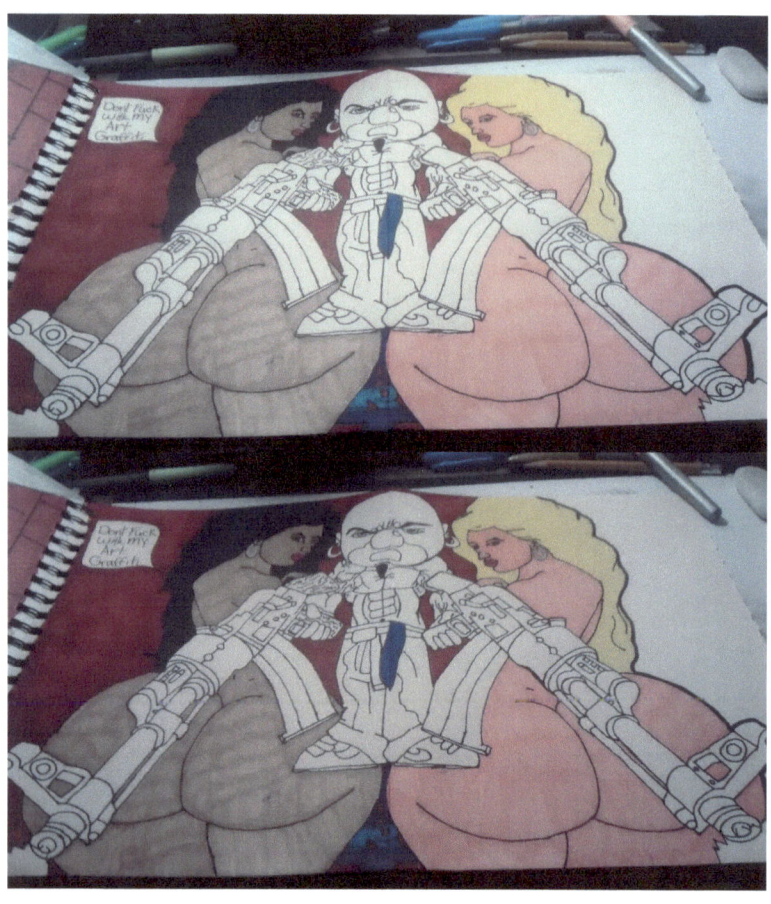

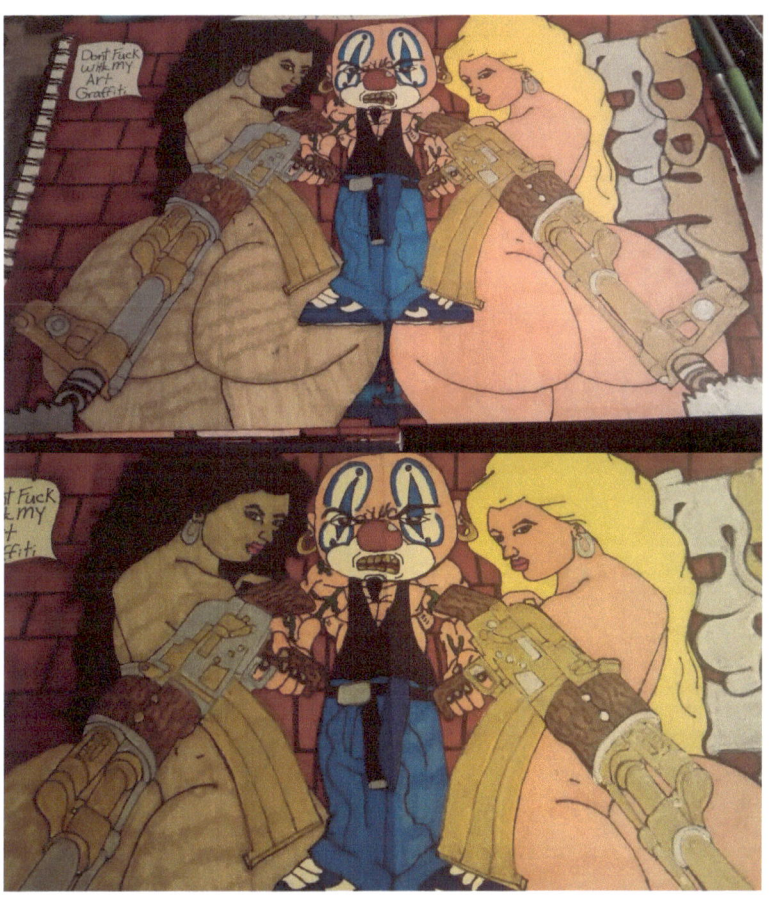

Jefe (shot caller)(boss) art by betojimenez

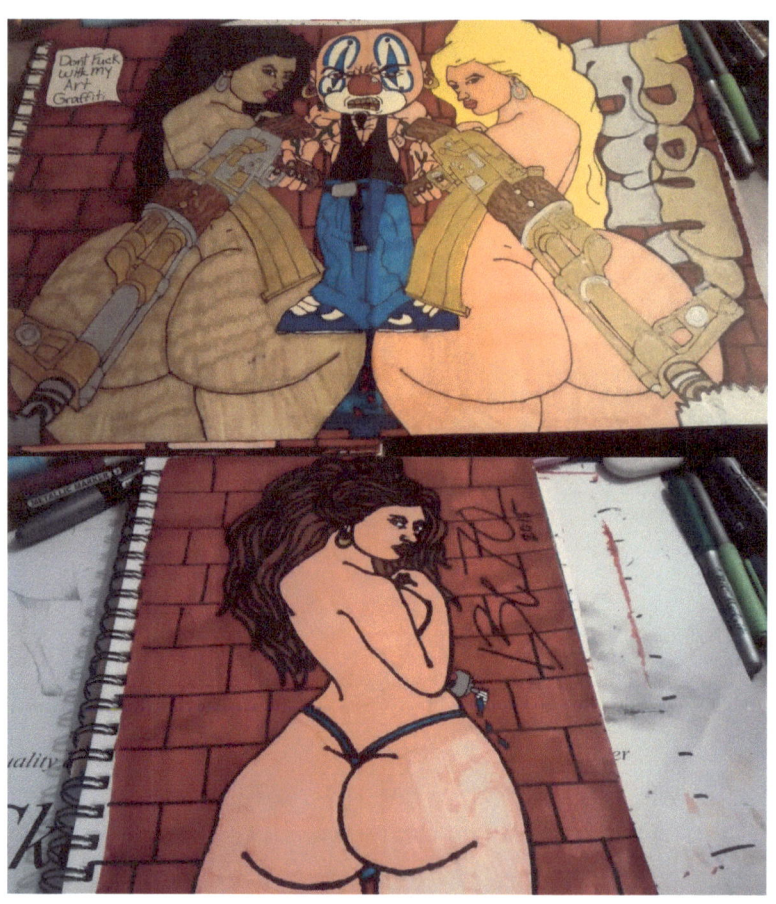

La chola art by betojimenez

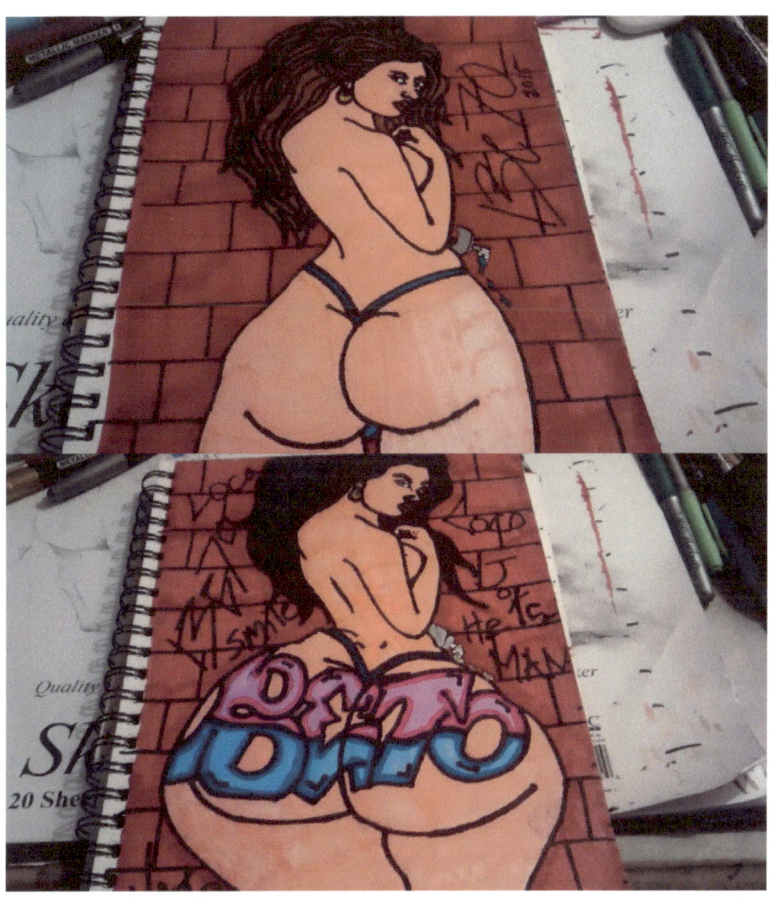

Me Ruca (wife or girlfriend of a cholo) art by betojimenez

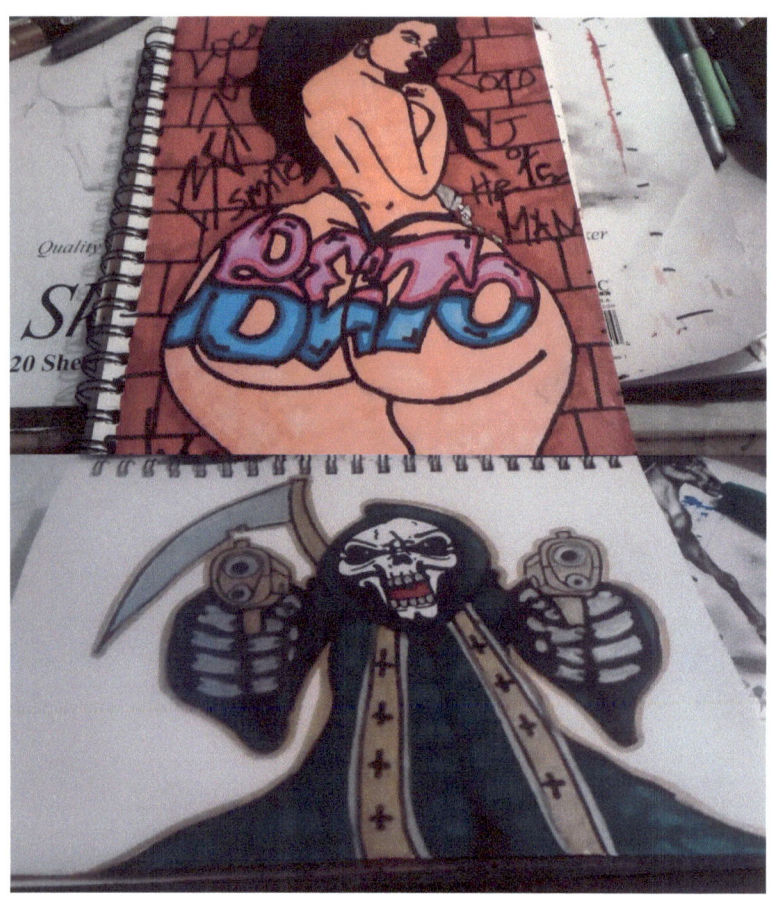

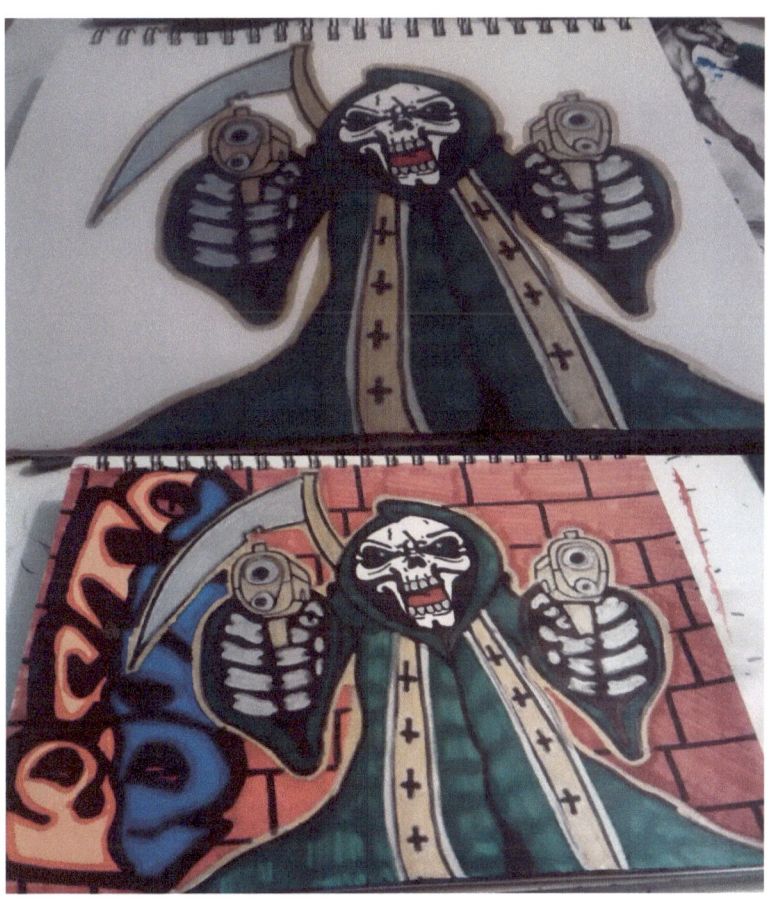

La santa muerte (a religion not a cult)
Art by betojimenez

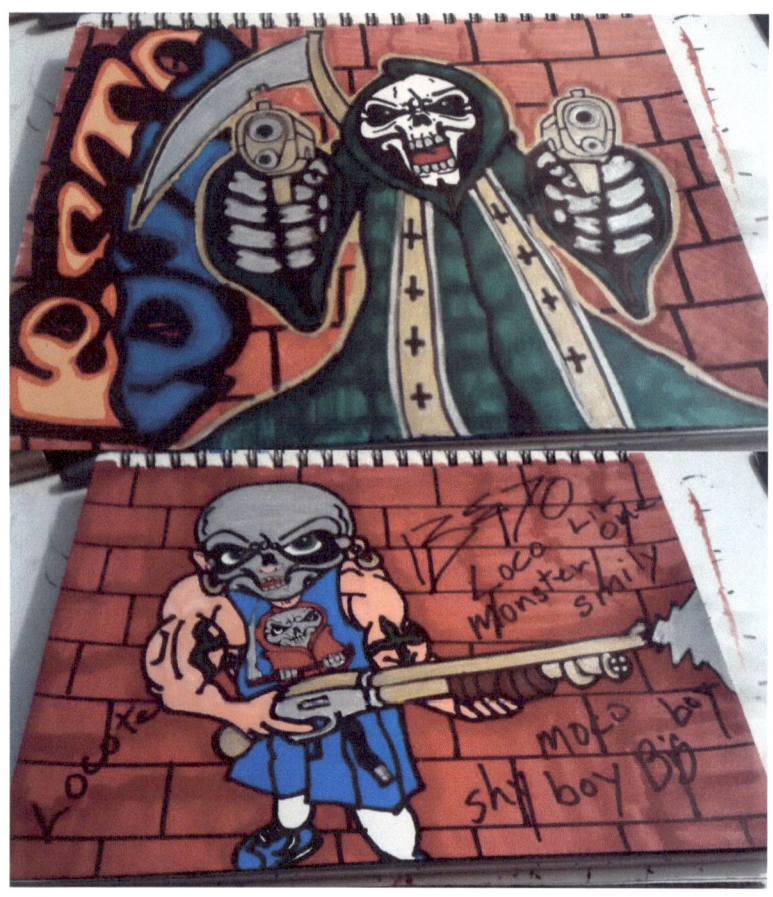

Cholo locote hitman art by betojimenez

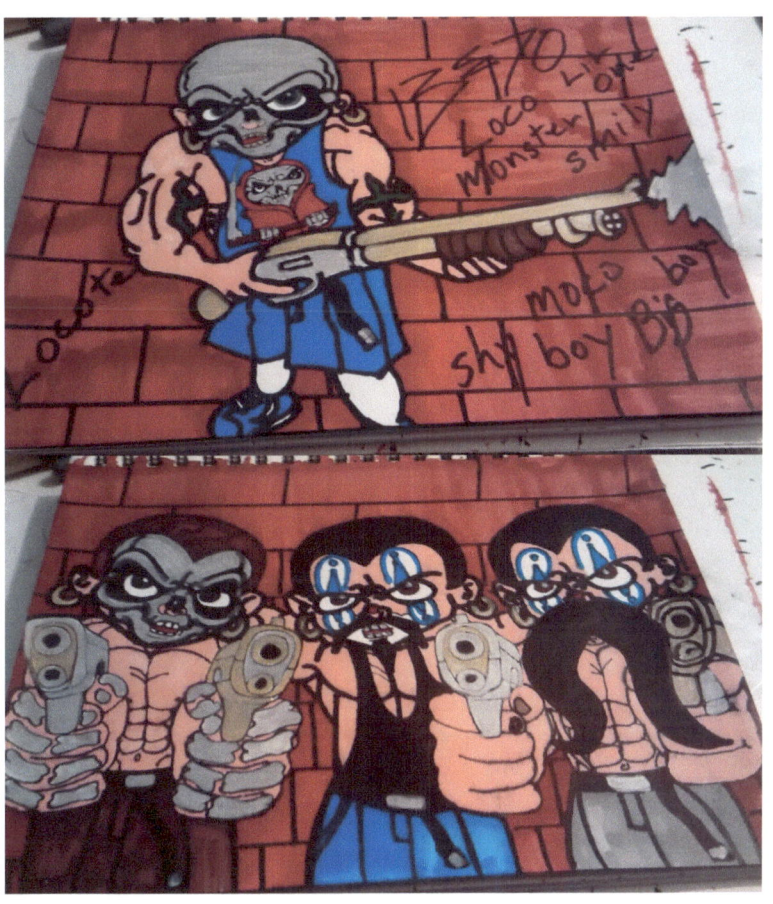

Los cholos (the gang, the homies) art by betojimenez

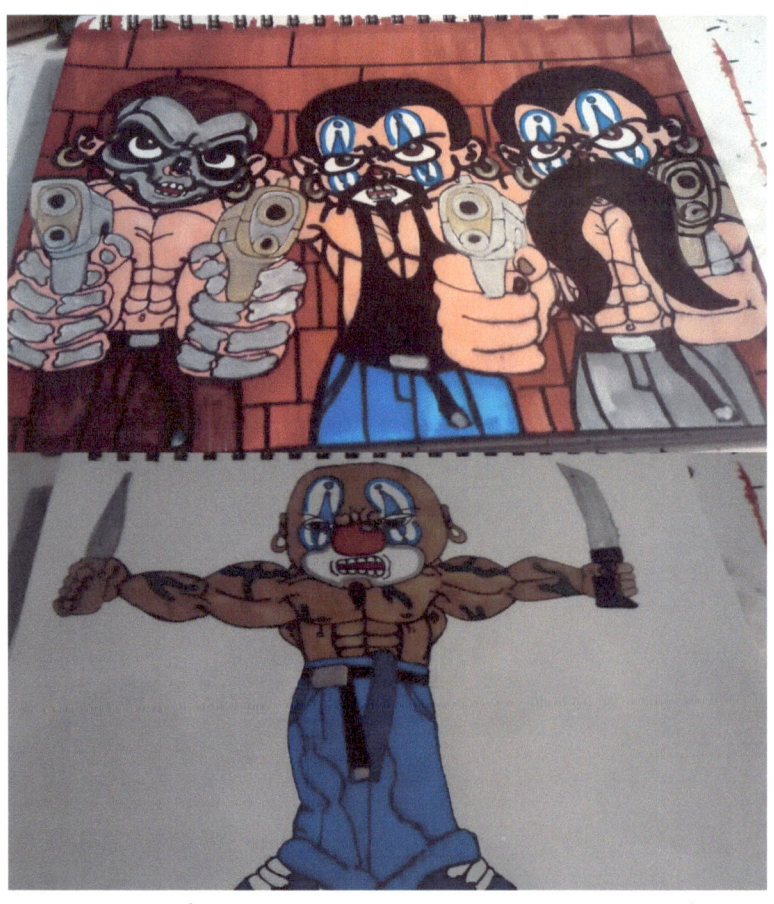

El Joker (crazyes cholo in the gang)art by betojimenez

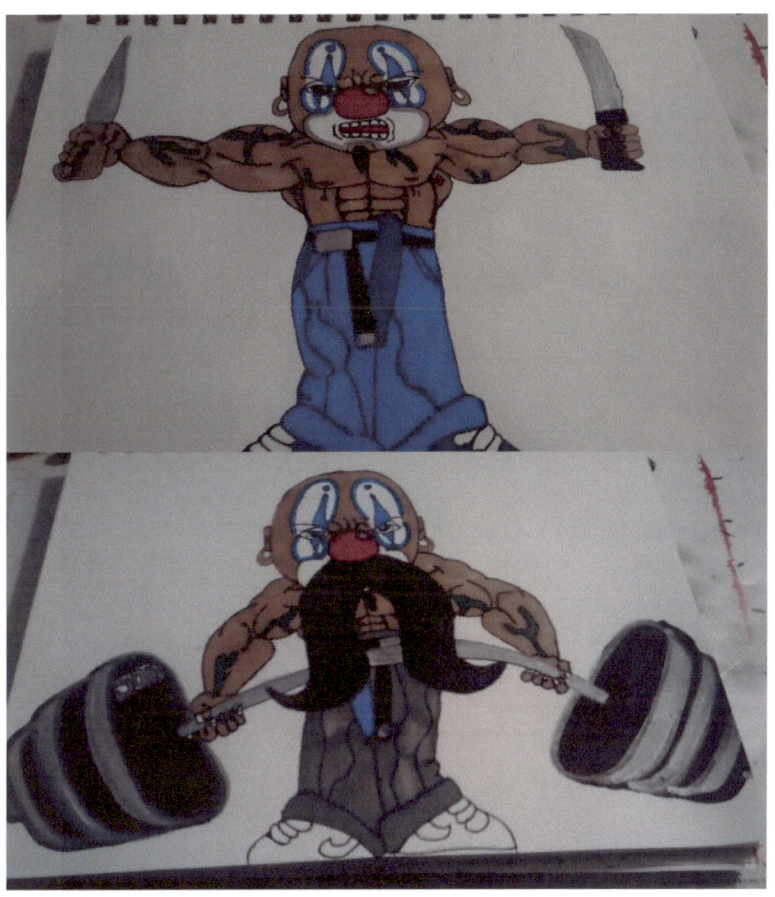

Cholo la pinta (CHOLO IN JAIL)art by be tojimenez

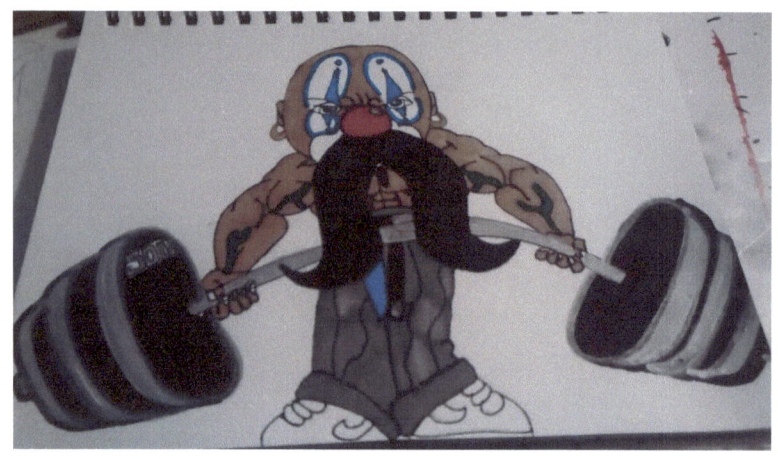

The muscle art by betojimenez

beto art websites

https://betojimenezartgallery.culturalspot.org/

**https://www.youtube.com/channel/UCJZoUmg3Q0l5wrzWfa5Fojw
http://www.amazon.com/Beto-Jimenez/e/B00975L33M/ref=ntt_dp_epwbk_0
http://www.artween.com/Artists/beto-jimenez**

http://studios.amazon.com/users/97031
http://www.i-m.co/betojimenez/graffitiartbetojimenez/
http://meylah.com/gallery51/store
http://www.ArtWanted.com/betojimenez
http://rtist.com/betojimenez
http://artist-listing.com/Artist.aspx?username=beto
http://www.artslant.com/global/artists/show/22484-beto-jimenez
http://artbetojimenez.blogspot.com/
http://betojimenezartgallery7.weebly.com/index.html
http://mightycleto.wix.com/betojimenezart
http://www.bonanza.com/booths/collectibles_1
http://betojimenez.fineartstudioonline.com/
http://comiccons.miiduu.com/

http://www.artmajeur.com/en/artist/betojimenez
http://ArtsCad.com/@/BetojimenezArt
http://www.manta.com/c/mxjlm5n/betojimenezartgallery
http://betojimenez.sell-arts.com/
http://betojimenez.deviantart.com/
http://betojimenez.artweb.com/
http://betojimenezgallery54.webstarttoday.com/home.html
http://www.amazon.com/Beto-Jimenez
http://fineartamerica.com/profiles/betojimenezartgallery.html
http://www.visualart.me/betojimenez
http://betojimenezartgallery.fineartamerica.com/
http://www.behance.net/betojimenez
http://www.redbubble.com/people/beto7

www.ingramcontent.com/pod-product-compliance
Lightning Source LLC
Chambersburg PA
CBHW041120180526
45172CB00001B/342